Mother Goose
in California

Mother Goose
in California

Conceived and Illustrated by
Doug Hansen

Heyday
Berkeley, California

Library of Congress Cataloging-in-Publication Data
Hansen, Doug.
 Mother Goose in California / conceived and illustrated by Doug Hansen.
 p. cm.
 Summary: An alphabet book featuring traditional Mother Goose rhymes with illustrations that relate to California culture and geography.
 ISBN 978-1-59714-101-7 (hardcover : alk. paper)
 1. Nursery rhymes. 2. Children's poetry. 3. California--Pictorial
works. [1. Nursery rhymes. 2. California--Pictorial works. 3. Alphabet.]
I. Title.
 PZ8.3.H1962Mo 2009
 398.8--dc22
 2008033638

Heyday is an independent, nonprofit publisher and unique cultural institution. We promote widespread awareness and celebration of California's many cultures, landscapes, and boundary-breaking ideas. Through our well-crafted books, public events, and innovative outreach programs we are building a vibrant community of readers, writers, and thinkers. To travel further into California, visit us at www. heydaybooks.com.

Book design by Lorraine Rath

Orders, inquiries, and correspondence should be addressed to:
 Heyday
 P.O. Box 9145, Berkeley, CA 94709
 (510) 549-3564, Fax (510) 549-1889
 www.heydaybooks.com

Manufactured by Regent Publishing Services, Hong Kong.
Printed in April 2012 in ShenZhen, Guangdong, China.

10 9 8 7 6 5 4 3

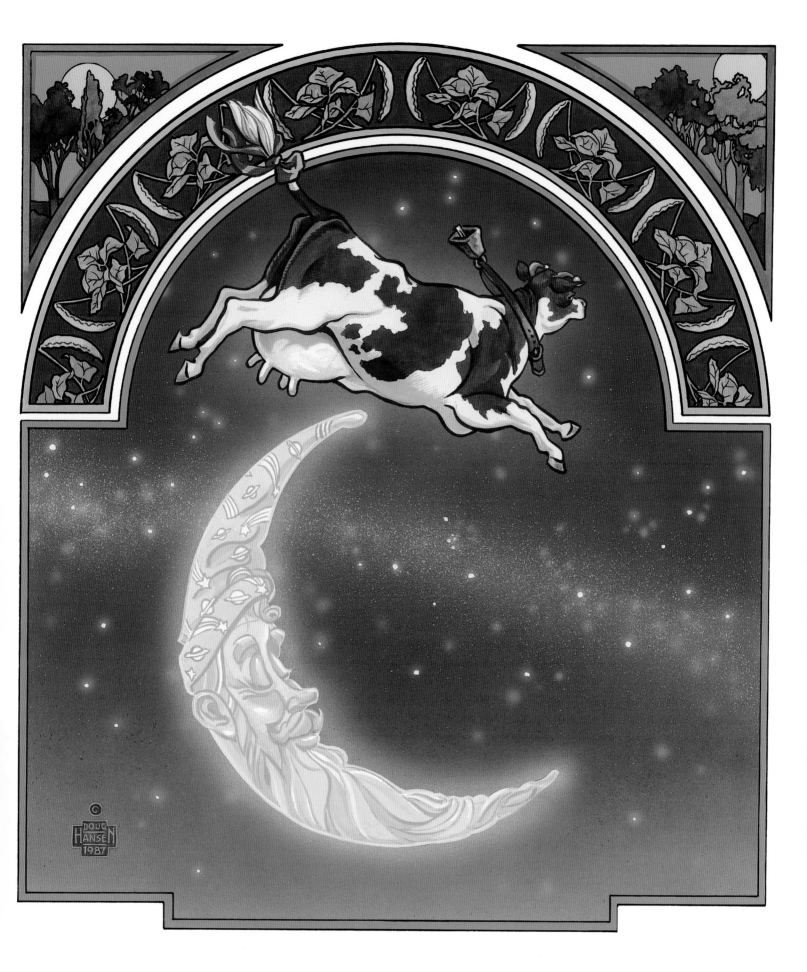

To Nathaniel and Wyeth Hansen,
two boys who learned their ABCs

Introduction

The Mother Goose illustrations I remember from childhood were set in the rustic English countryside or in a fanciful medieval Europe. Those beguiling rhymes and fantastical images lingered in my memory and have insistently evolved into the pictures in this book.

I'm a native Californian, and I asked myself what Mother Goose and her rhymes would look like in a western setting. I soon appreciated that the larger-than-life history of my state and the unlimited variety and drama of the landscape were my path to re-imagining the well-known nursery rhymes.

In *Mother Goose in California*, each letter of the alphabet is connected to a word found in a nursery rhyme, and each illustration depicts my vision of an imaginary place—but one still rooted in the real world. What a puzzle it was to choose the words and rhymes that conjured the most appealing images. Some favorites were reluctantly set aside for less familiar rhymes that presented unique opportunities for visual storytelling. If you have a fondness for ABC books, you may be intrigued by Mother Goose's choices for those troublesome letters X and Z.

My pictures are set in historic, romantic, and scenic California. All of the animals and plants that appear in these rhymes are still to be found in California, save for the grizzly. Some of the most interesting creatures are rarely seen outside of the state. I enjoyed assigning them their roles in Mother Goose's little dramas.

Creating these pictures has been a satisfying and joyful experience and one of the high points of my artistic life. I hope you will enjoy discovering California with Mother Goose. If you or a child wish to identify the animals or know more about the details of the pictures, you can learn more by turning to the back pages of the book. Mother Goose has stories about each letter to share with you.

Doug Hansen
February 2008

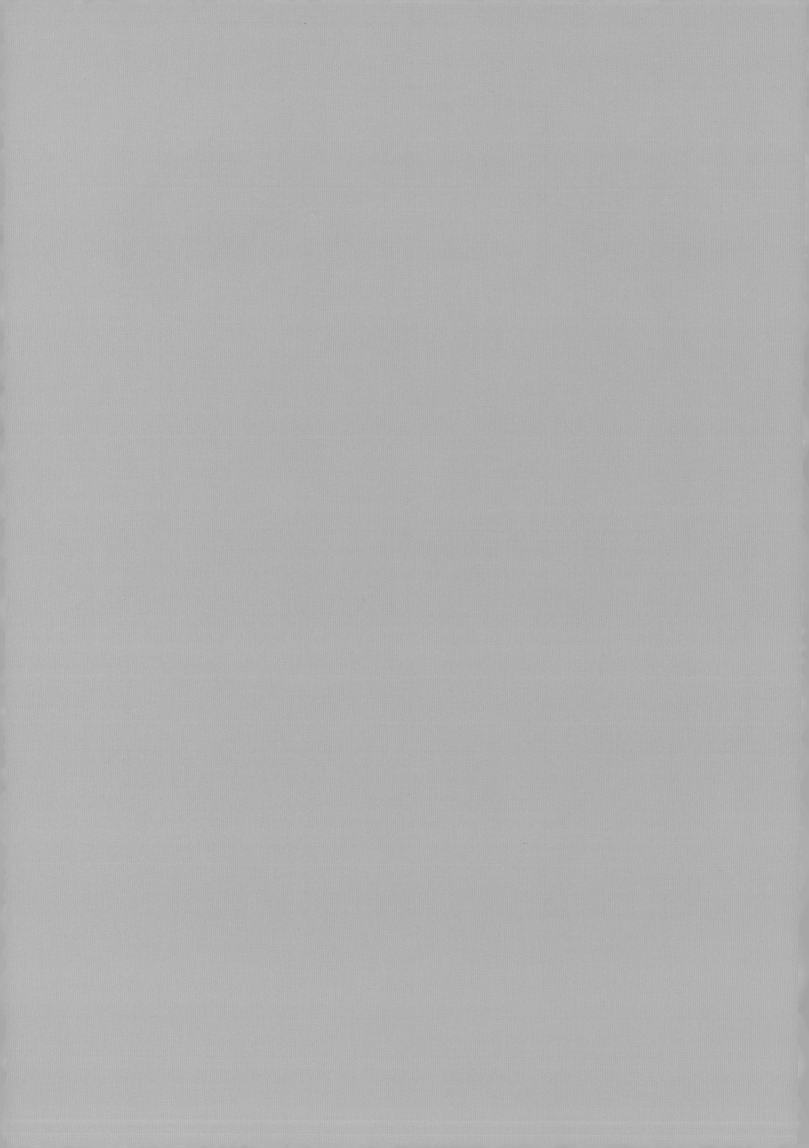

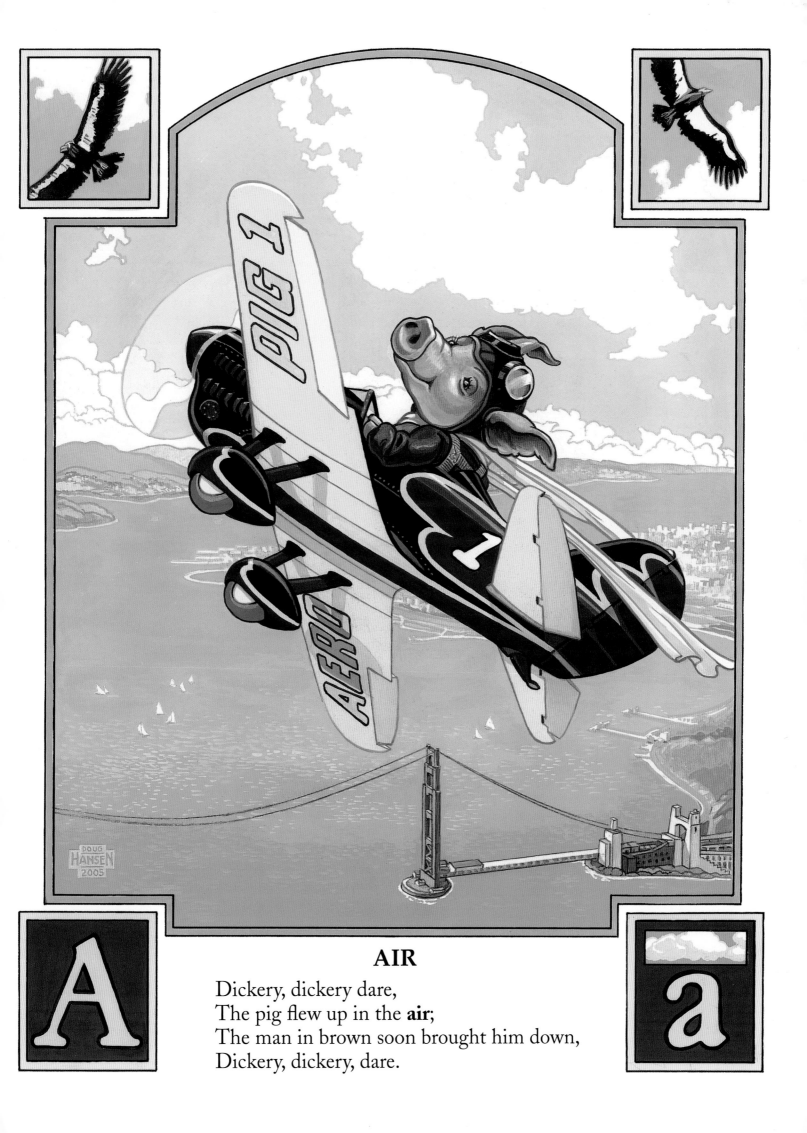

AIR

Dickery, dickery dare,
The pig flew up in the **air**;
The man in brown soon brought him down,
Dickery, dickery, dare.

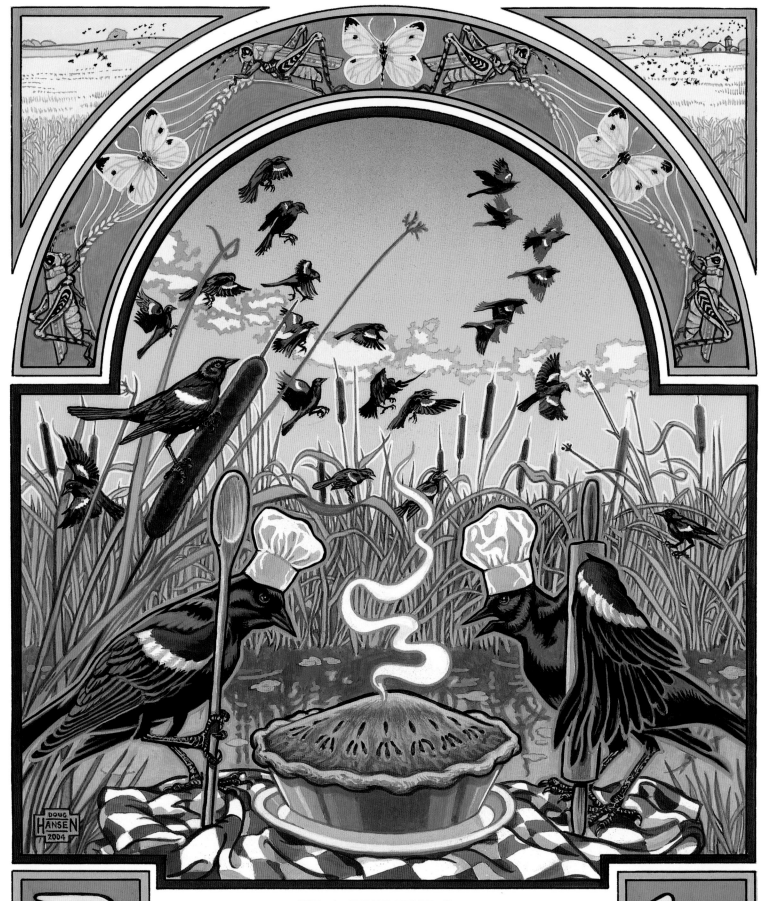

BLACKBIRDS

Sing a song of sixpence, a pocket full of rye;
Four and twenty **blackbirds** baked in a pie!
When the pie was opened the birds began to sing:
Wasn't that a dainty dish to set before the king?

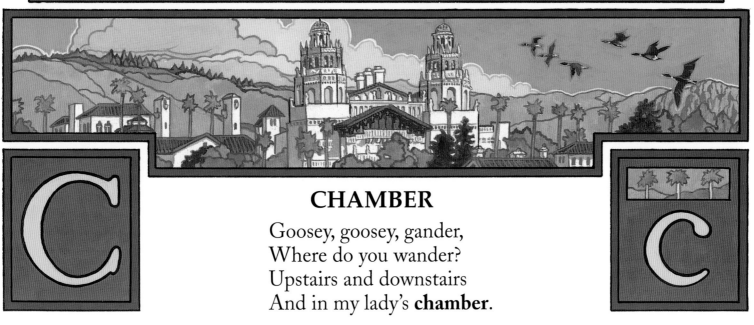

CHAMBER

Goosey, goosey, gander,
Where do you wander?
Upstairs and downstairs
And in my lady's **chamber**.

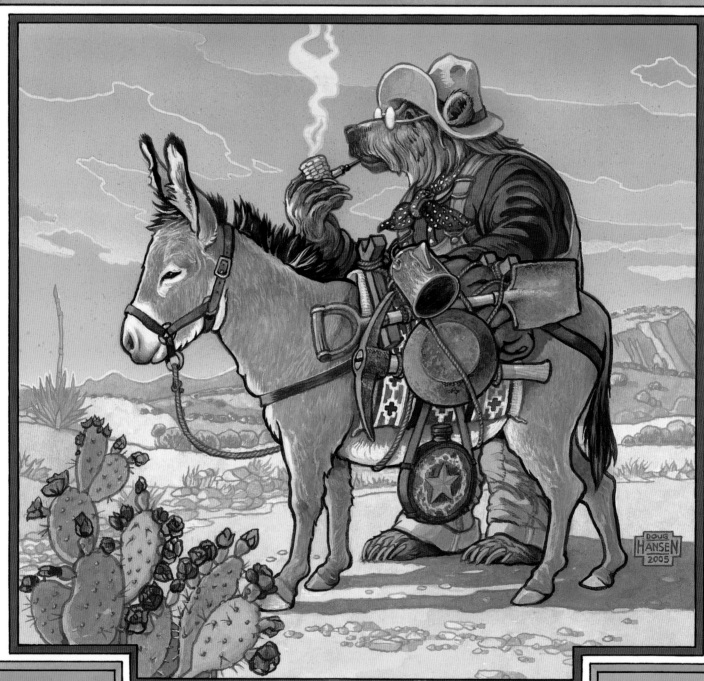

DONKEY

Donkey, donkey, old and gray,
Open your mouth and gently bray;
Lift your ears and blow your horn,
To wake the world this sleepy morn.

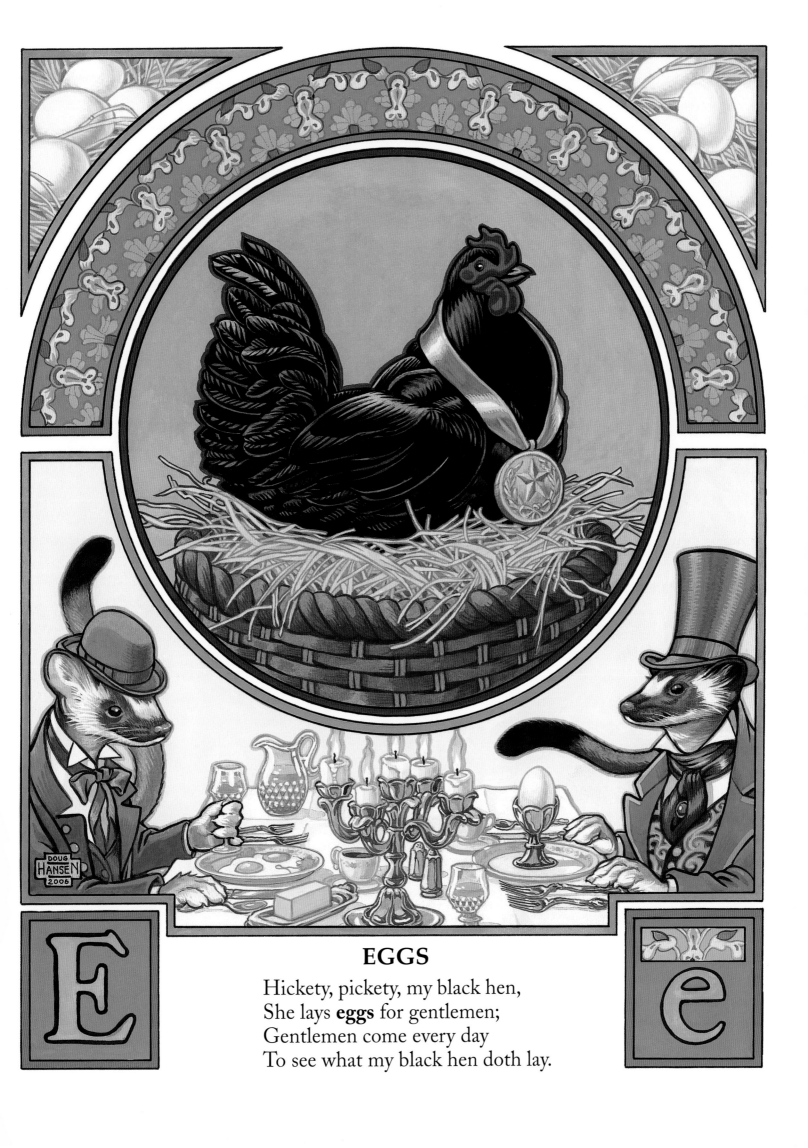

EGGS

Hickety, pickety, my black hen,
She lays **eggs** for gentlemen;
Gentlemen come every day
To see what my black hen doth lay.

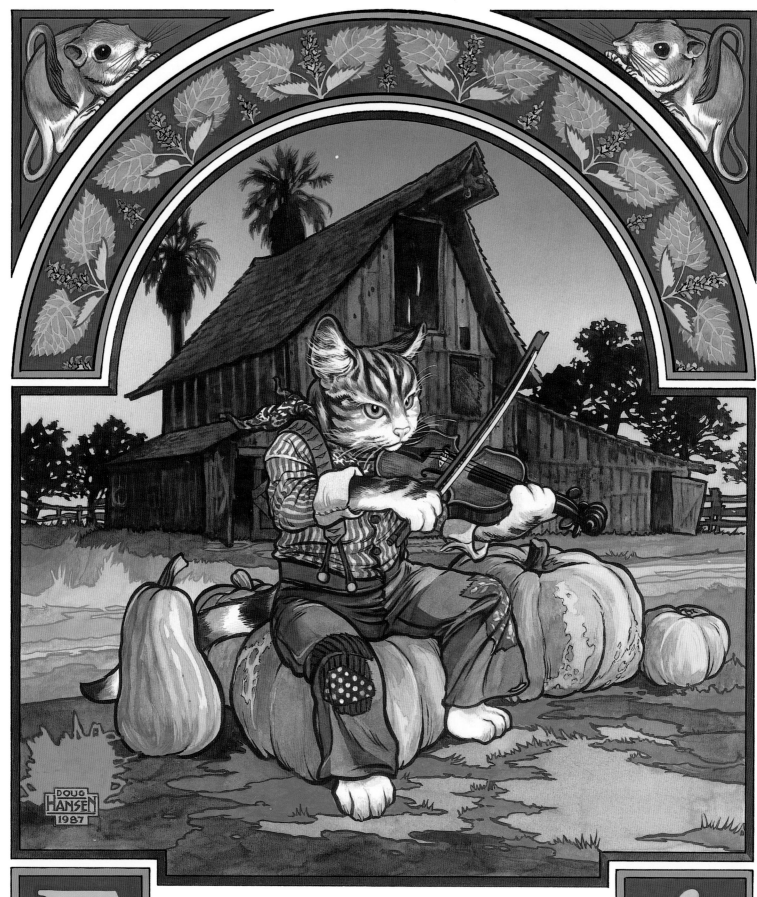

FIDDLE

Hey diddle diddle! The cat and the **fiddle**,
The cow jumped over the moon;
The little dog laughed to see such sport
And the dish ran away with the spoon.

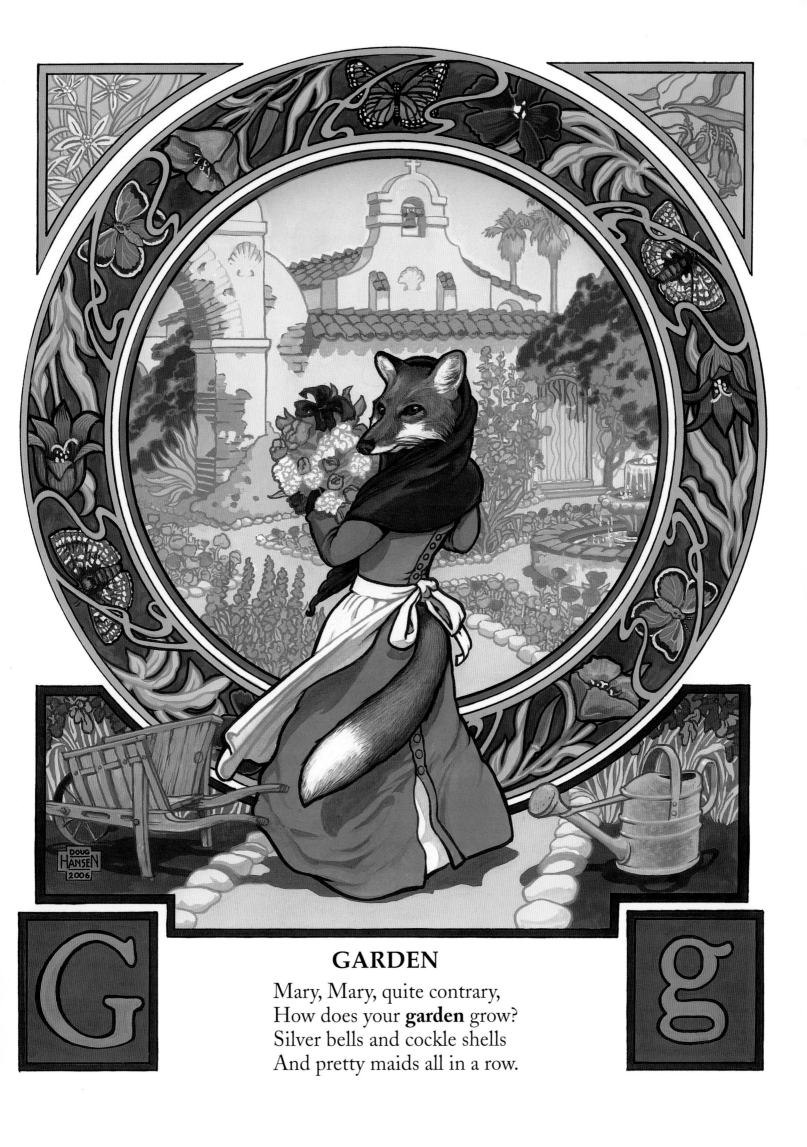

GARDEN

Mary, Mary, quite contrary,
How does your **garden** grow?
Silver bells and cockle shells
And pretty maids all in a row.

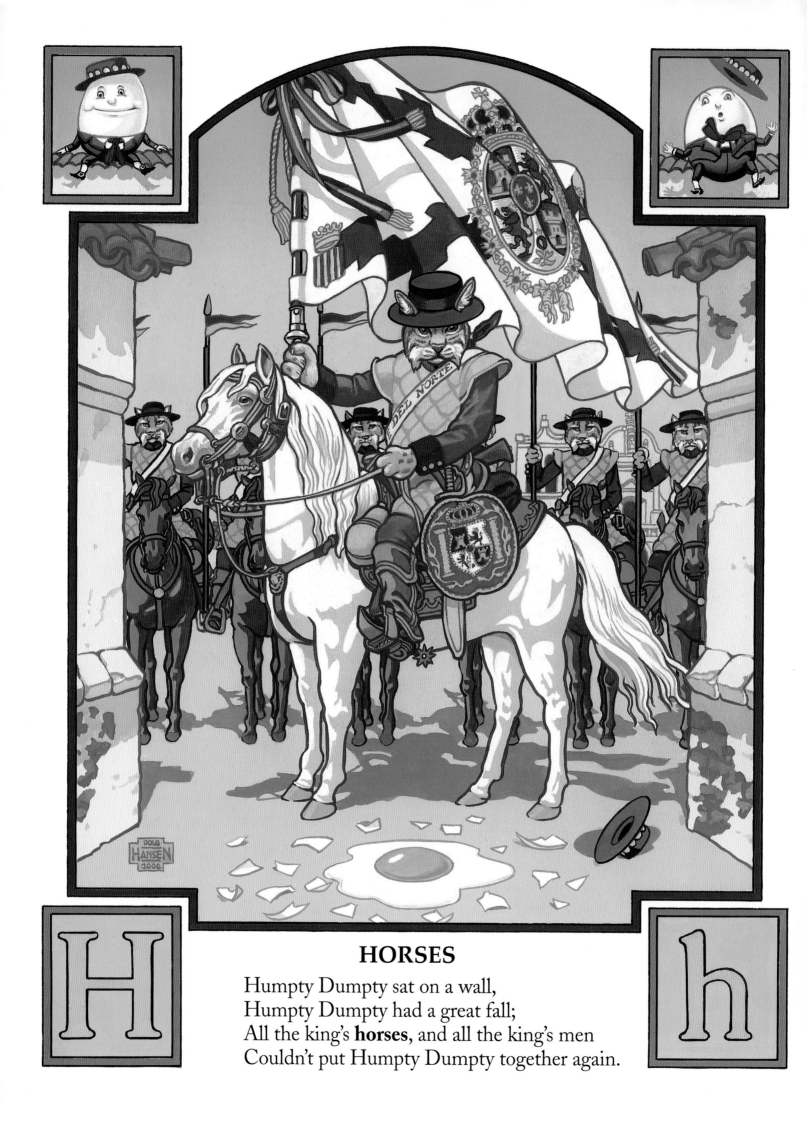

HORSES

Humpty Dumpty sat on a wall,
Humpty Dumpty had a great fall;
All the king's **horses**, and all the king's men
Couldn't put Humpty Dumpty together again.

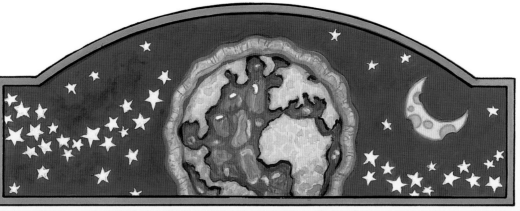

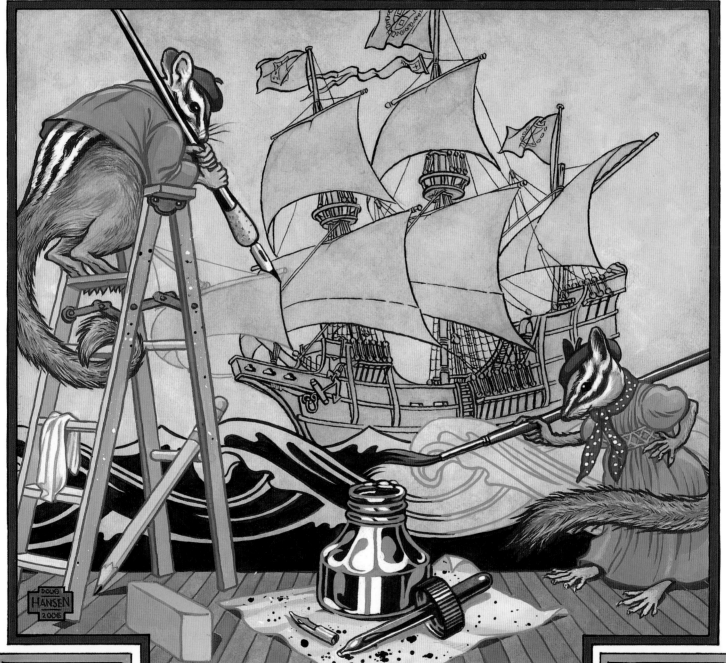

INK

If all the world were apple pie,
And all the sea were **ink**,
And all the trees were bread and cheese,
What should we have to drink?

I

i

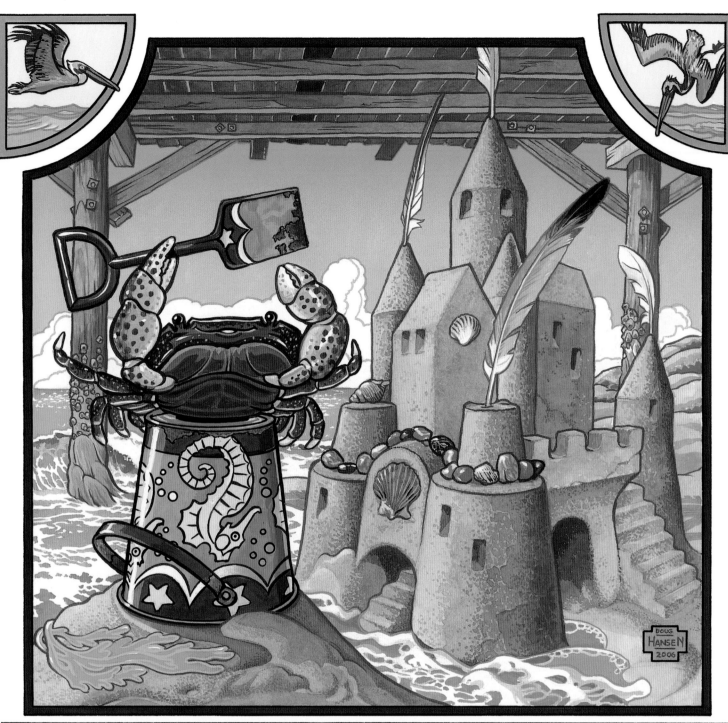

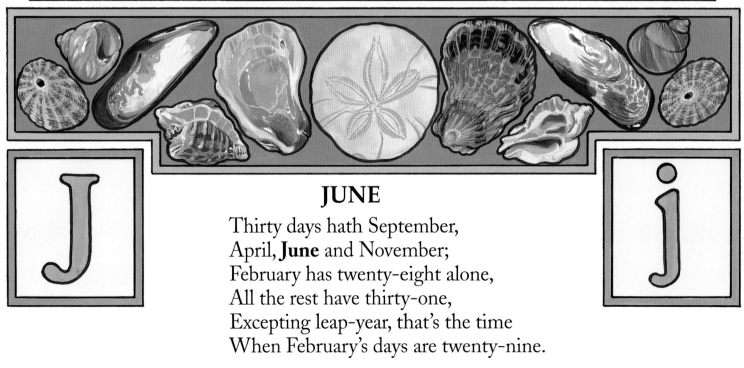

JUNE

Thirty days hath September,
April, **June** and November;
February has twenty-eight alone,
All the rest have thirty-one,
Excepting leap-year, that's the time
When February's days are twenty-nine.

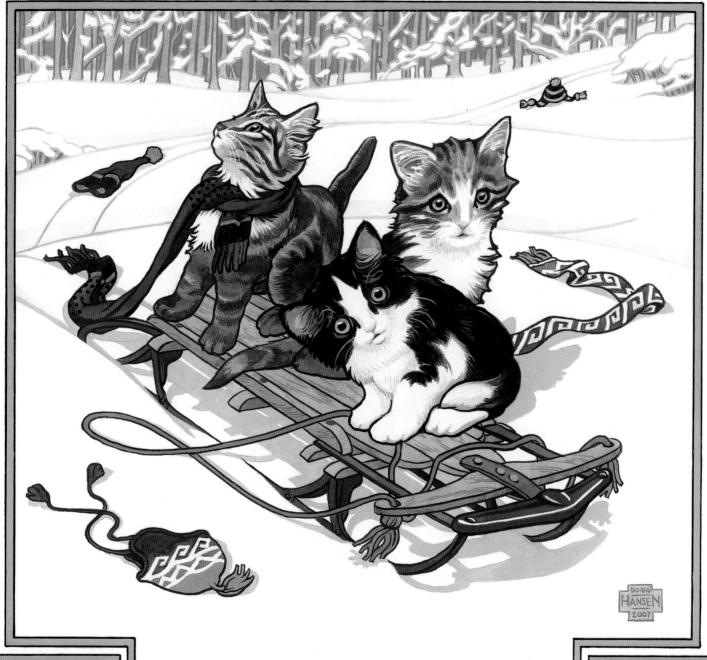

KITTENS

These three little **kittens**
lost their mittens,
And they began to cry,
Mee-ow, mee-ow, mee-ow.

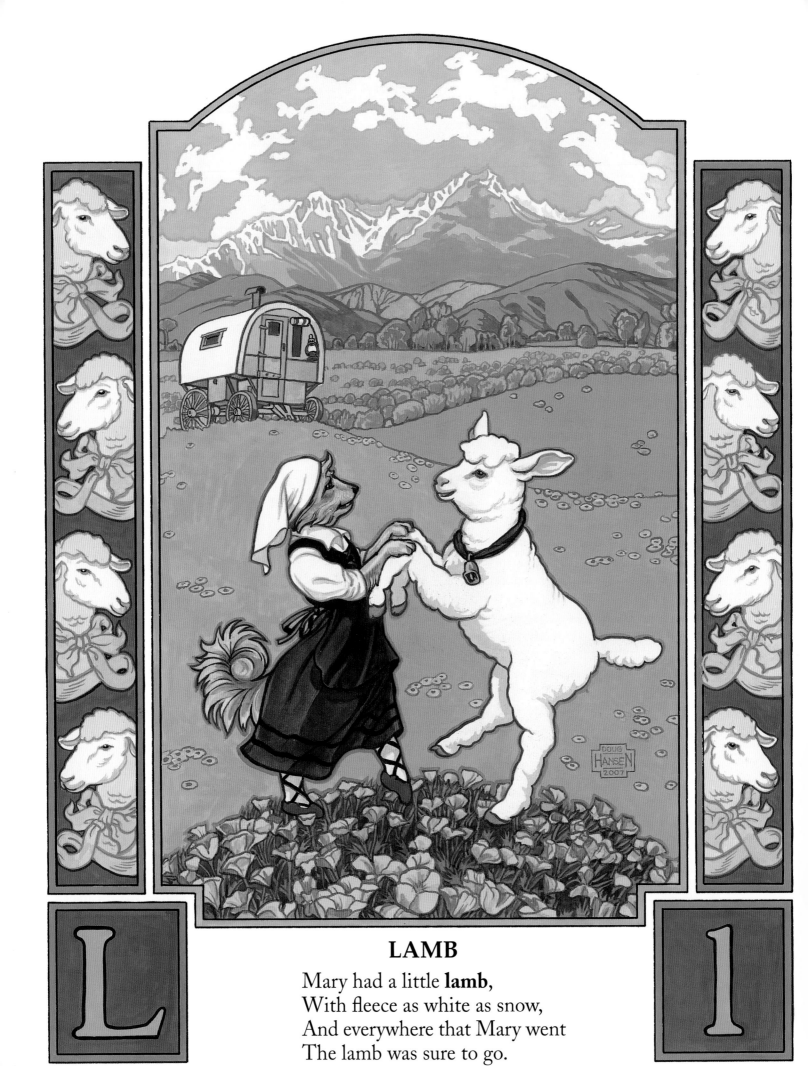

LAMB

Mary had a little **lamb**,
With fleece as white as snow,
And everywhere that Mary went
The lamb was sure to go.

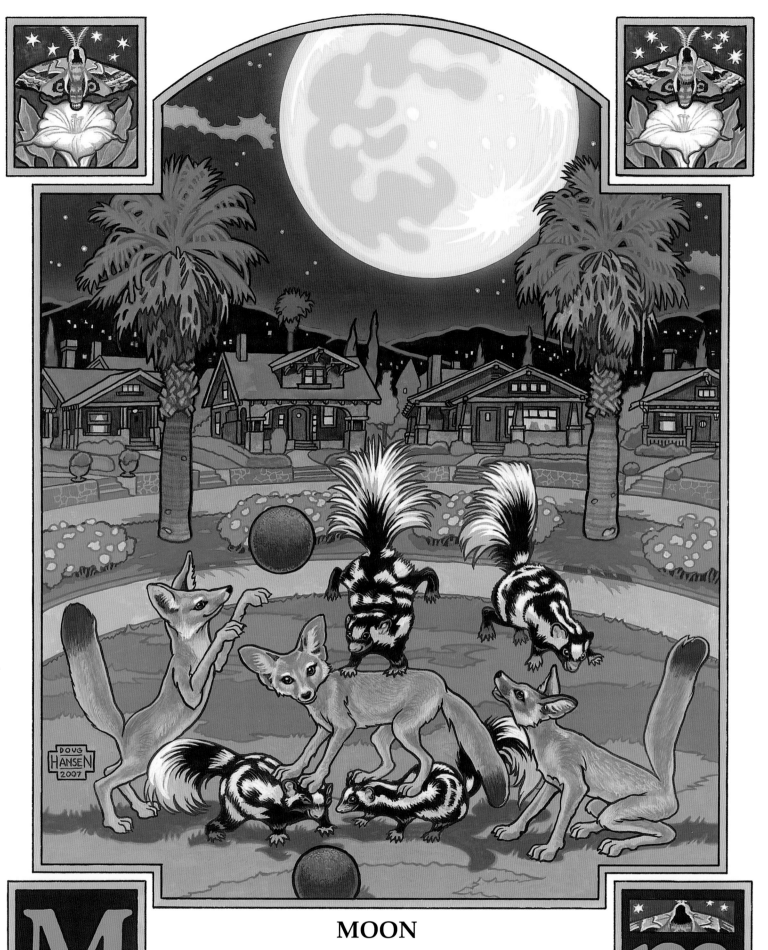

MOON

Boys and girls come out to play,
The **moon** doth shine as bright as day;
Leave your supper and leave your sleep,
And meet your playfellows in the street.

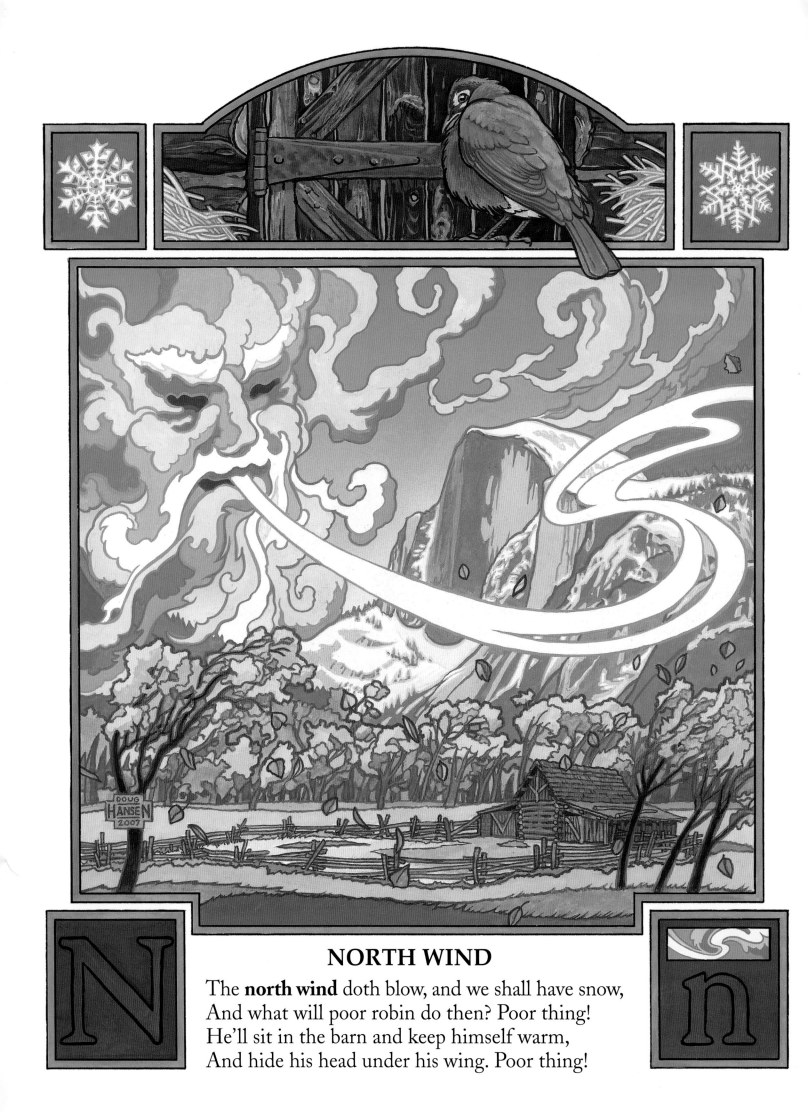

NORTH WIND

The **north wind** doth blow, and we shall have snow,
And what will poor robin do then? Poor thing!
He'll sit in the barn and keep himself warm,
And hide his head under his wing. Poor thing!

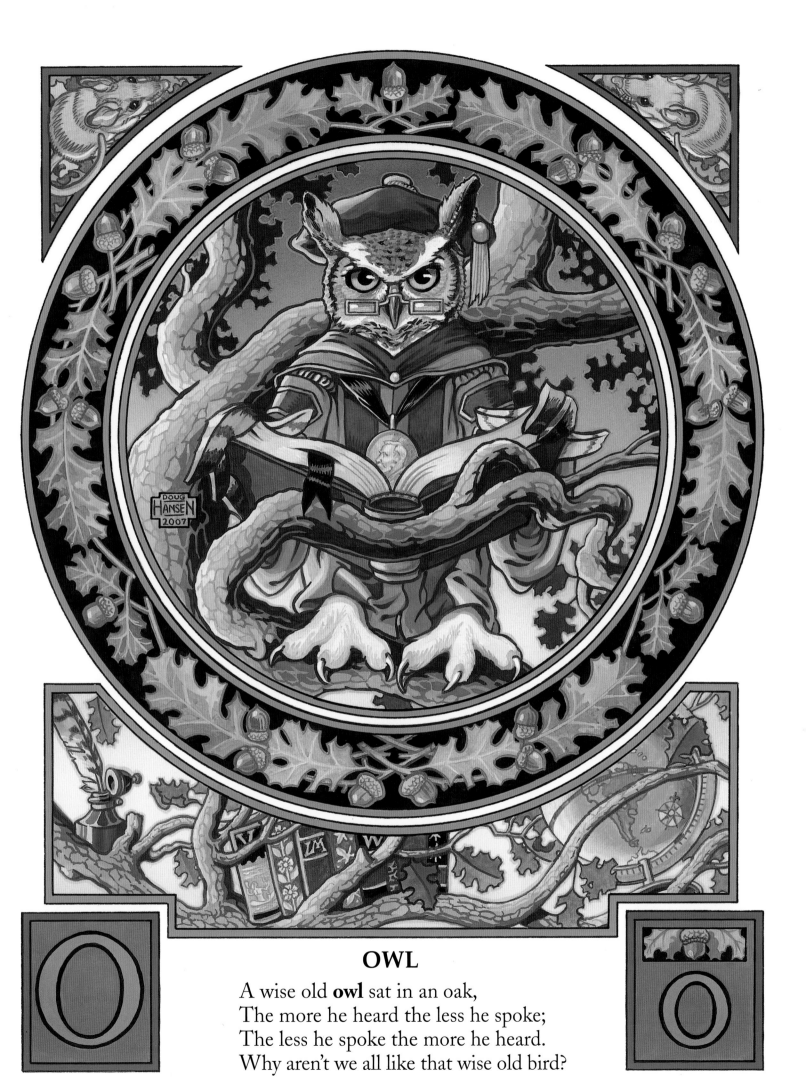

OWL

A wise old **owl** sat in an oak,
The more he heard the less he spoke;
The less he spoke the more he heard.
Why aren't we all like that wise old bird?

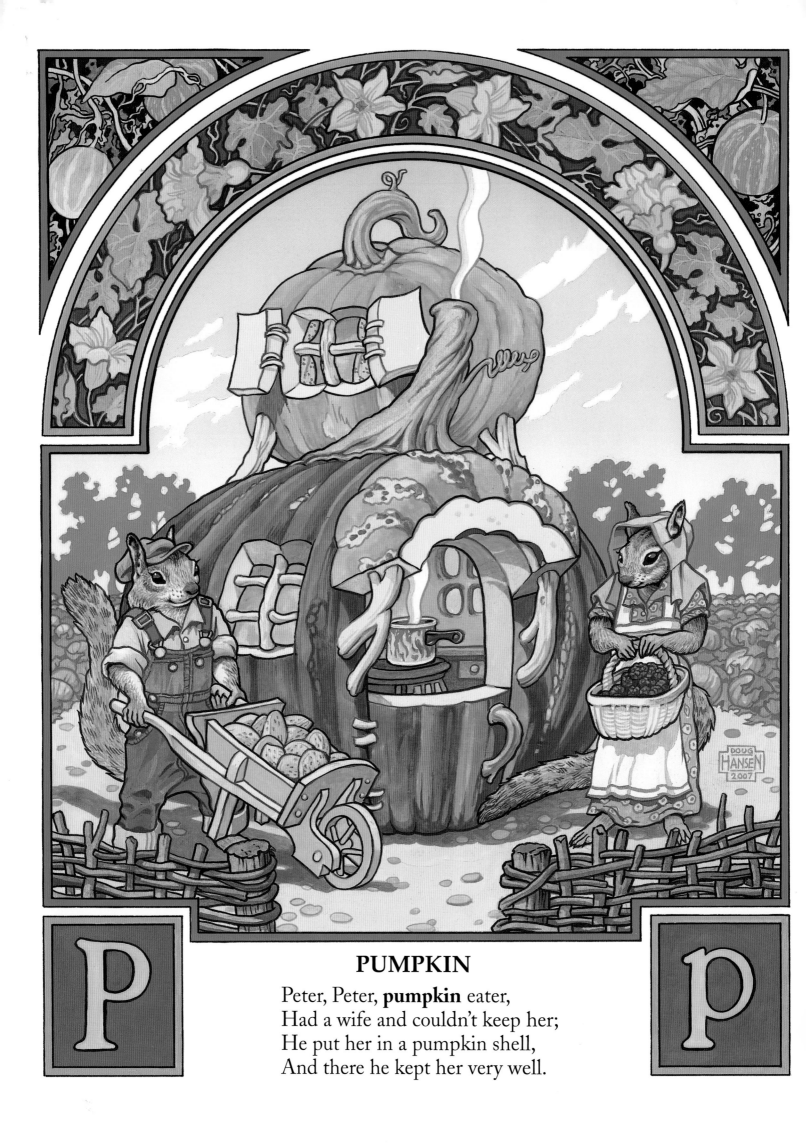

PUMPKIN

Peter, Peter, **pumpkin** eater,
Had a wife and couldn't keep her;
He put her in a pumpkin shell,
And there he kept her very well.

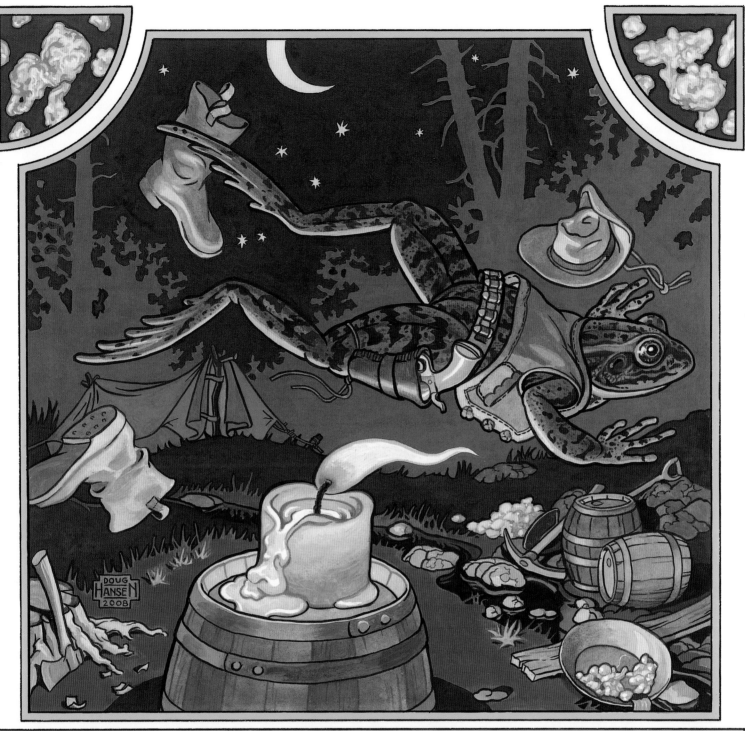

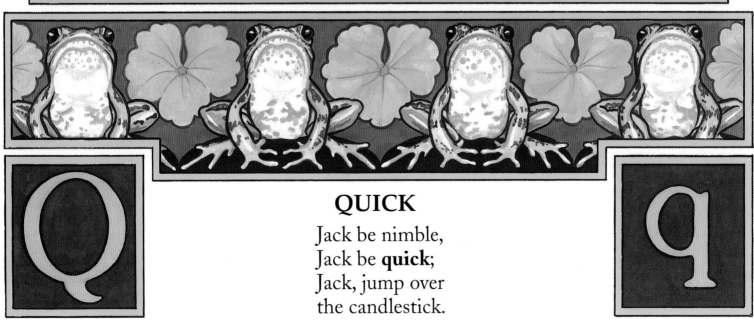

QUICK

Jack be nimble,
Jack be **quick**;
Jack, jump over
the candlestick.

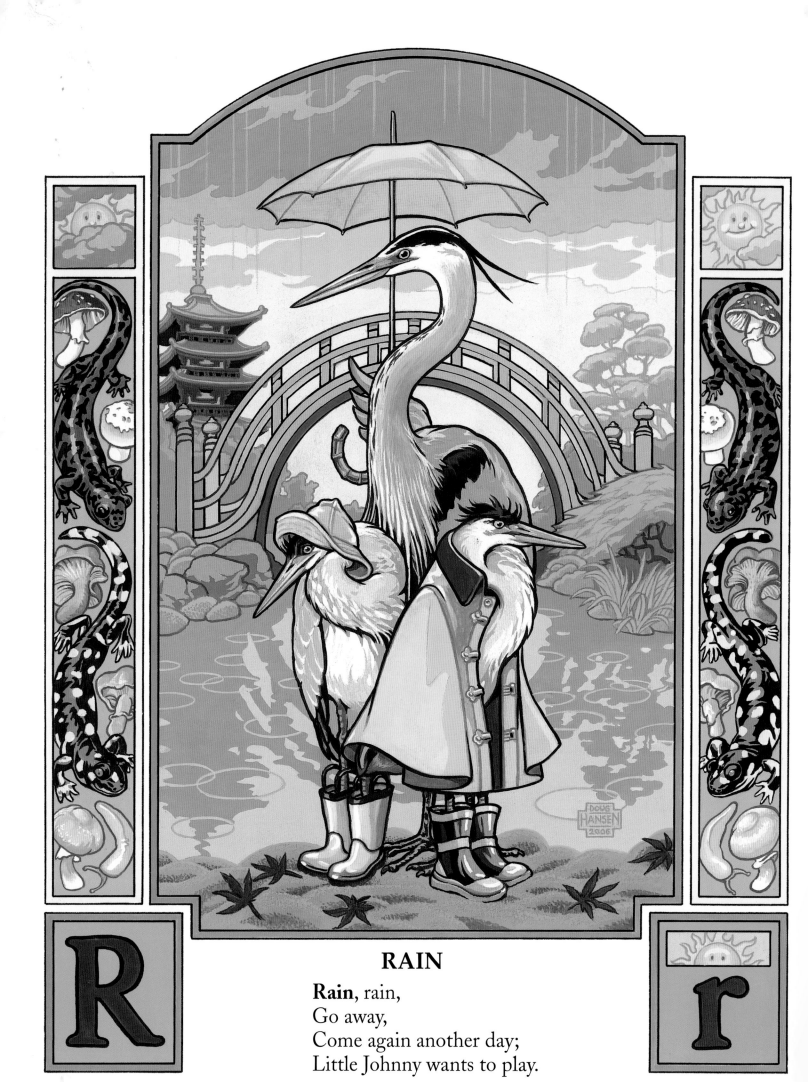

RAIN

Rain, rain,
Go away,
Come again another day;
Little Johnny wants to play.

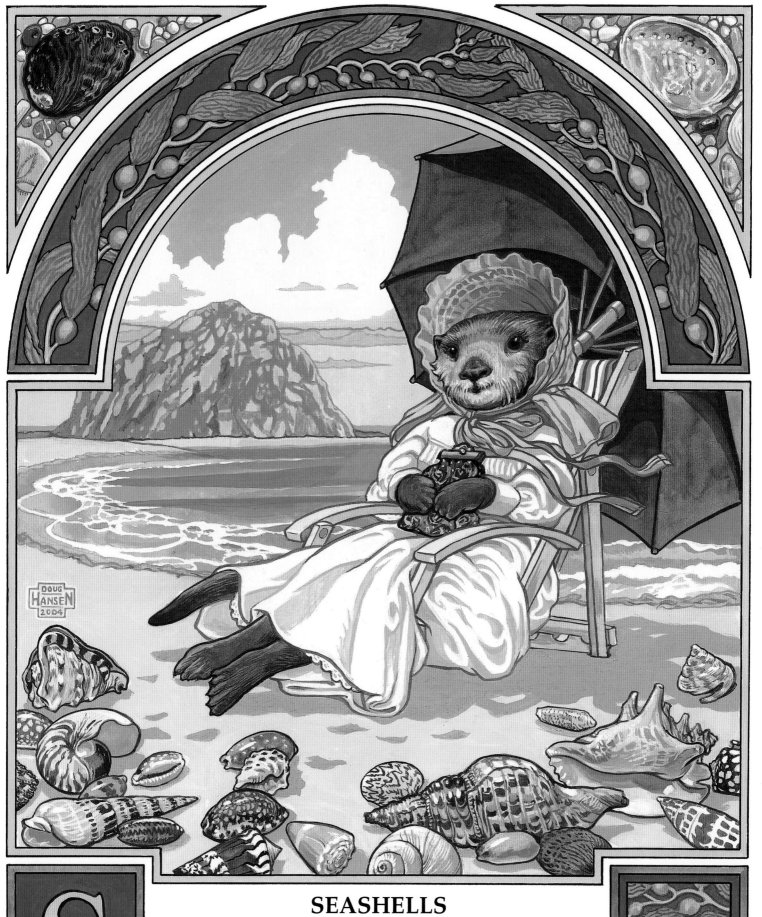

SEASHELLS

She sells **seashells**
on the seashore;
The shells that she sells
are seashells I'm sure.

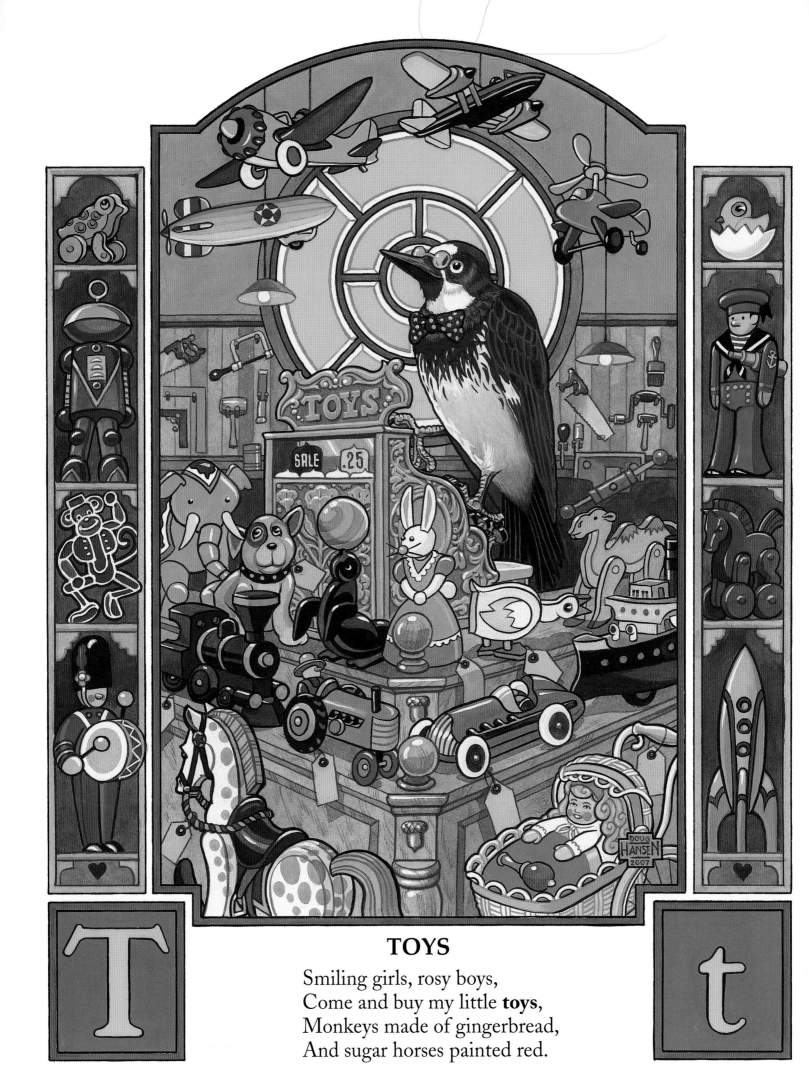

TOYS

Smiling girls, rosy boys,
Come and buy my little **toys**,
Monkeys made of gingerbread,
And sugar horses painted red.

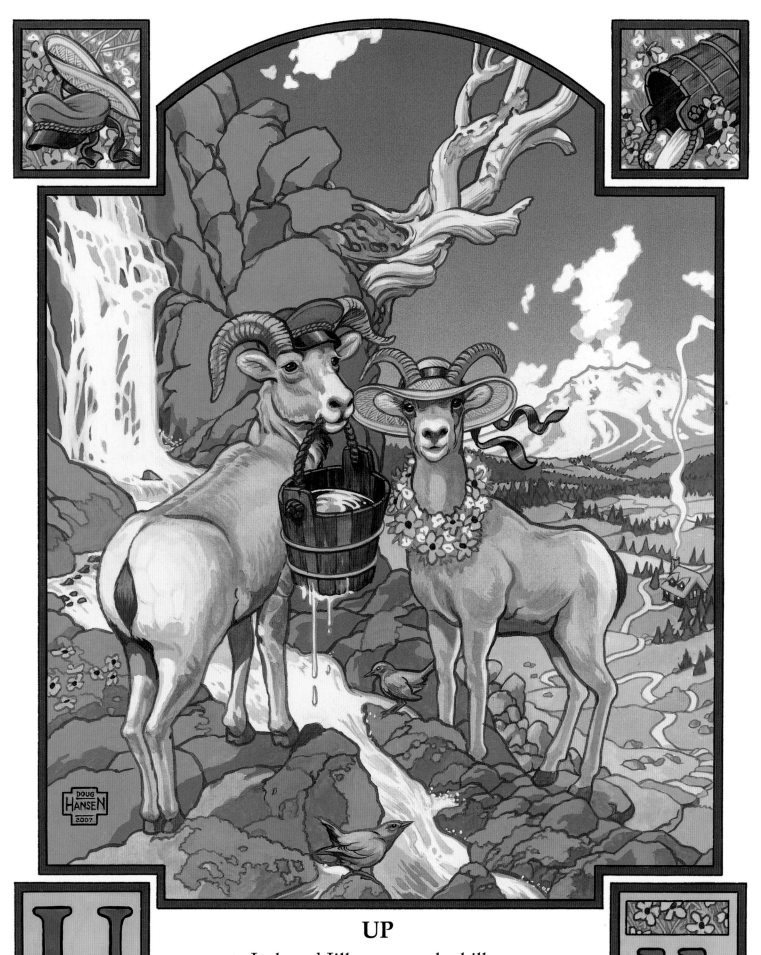

UP

Jack and Jill went **up** the hill
To fetch a pail of water;
Jack fell down and broke his crown,
And Jill came tumbling after.

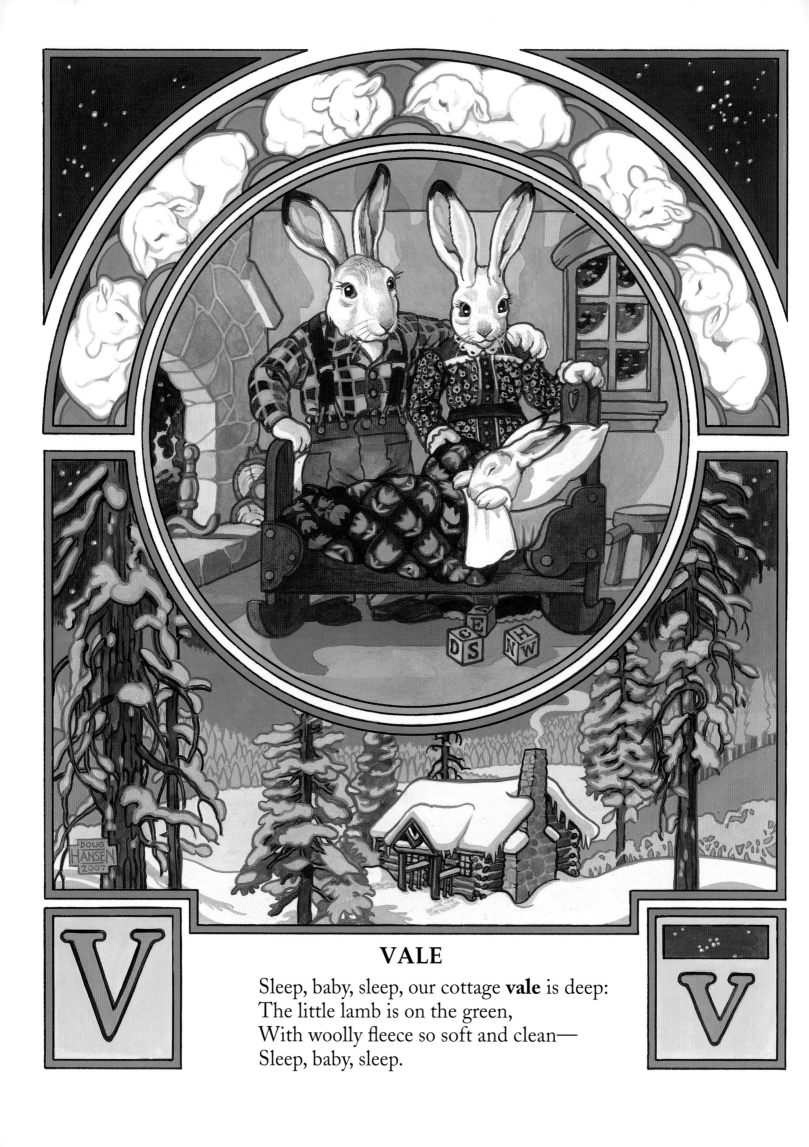

VALE

Sleep, baby, sleep, our cottage **vale** is deep:
The little lamb is on the green,
With woolly fleece so soft and clean—
Sleep, baby, sleep.

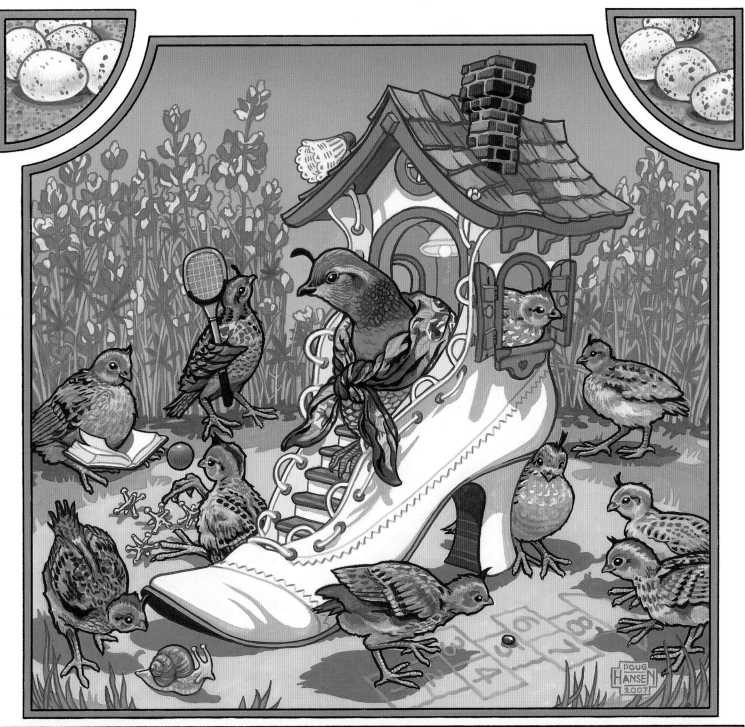

WOMAN

There was an old **woman**
who lived in a shoe,
She had so many children
she didn't know what to do.

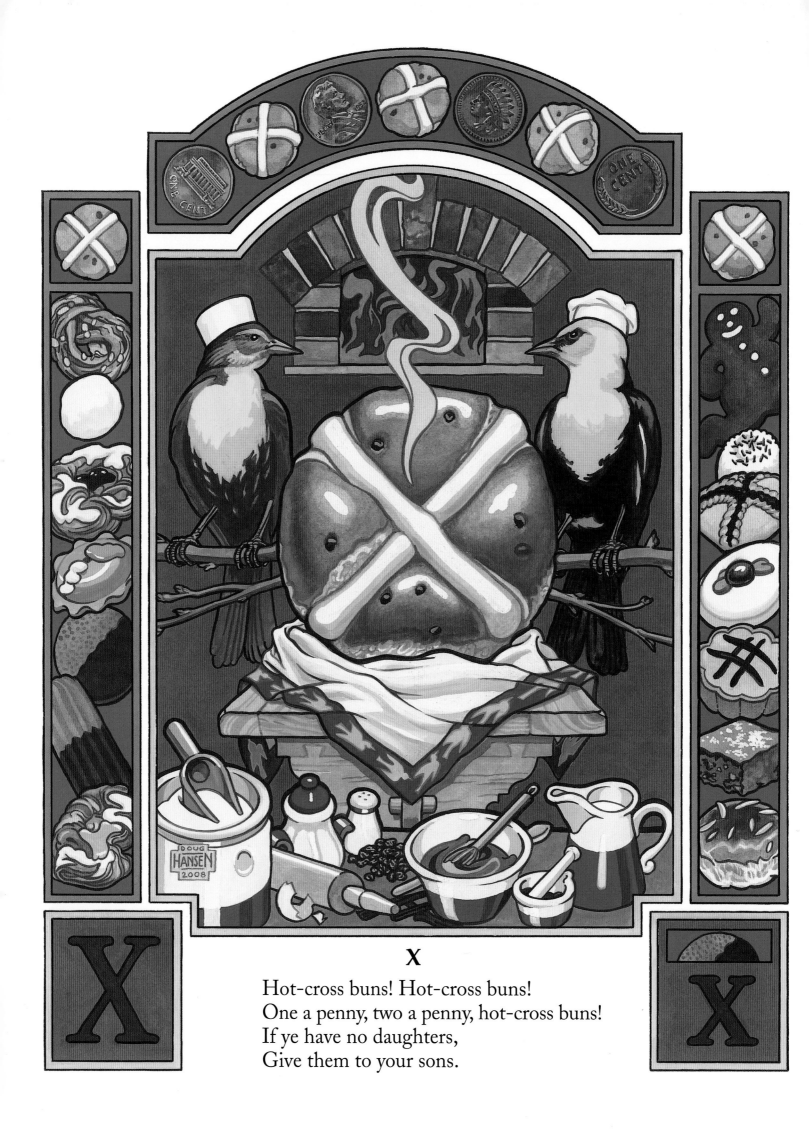

X

Hot-cross buns! Hot-cross buns!
One a penny, two a penny, hot-cross buns!
If ye have no daughters,
Give them to your sons.

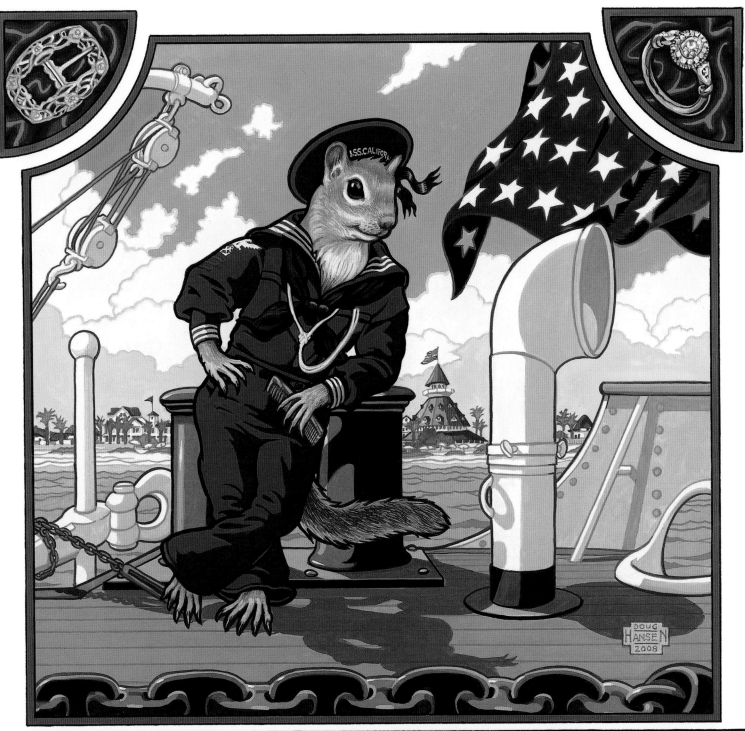

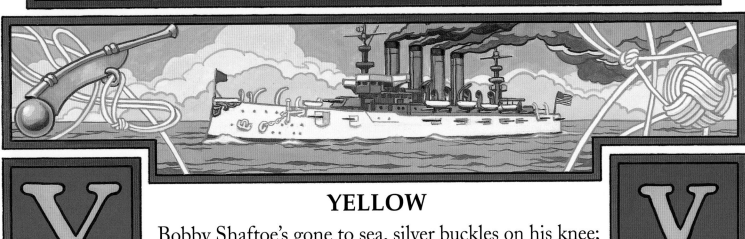

YELLOW

Bobby Shaftoe's gone to sea, silver buckles on his knee;
He'll come back and marry me, pretty Bobby Shaftoe.
Bobby Shaftoe's fat and fair,
Combing down his **yellow** hair,
He's my love forevermore, pretty Bobby Shaftoe.

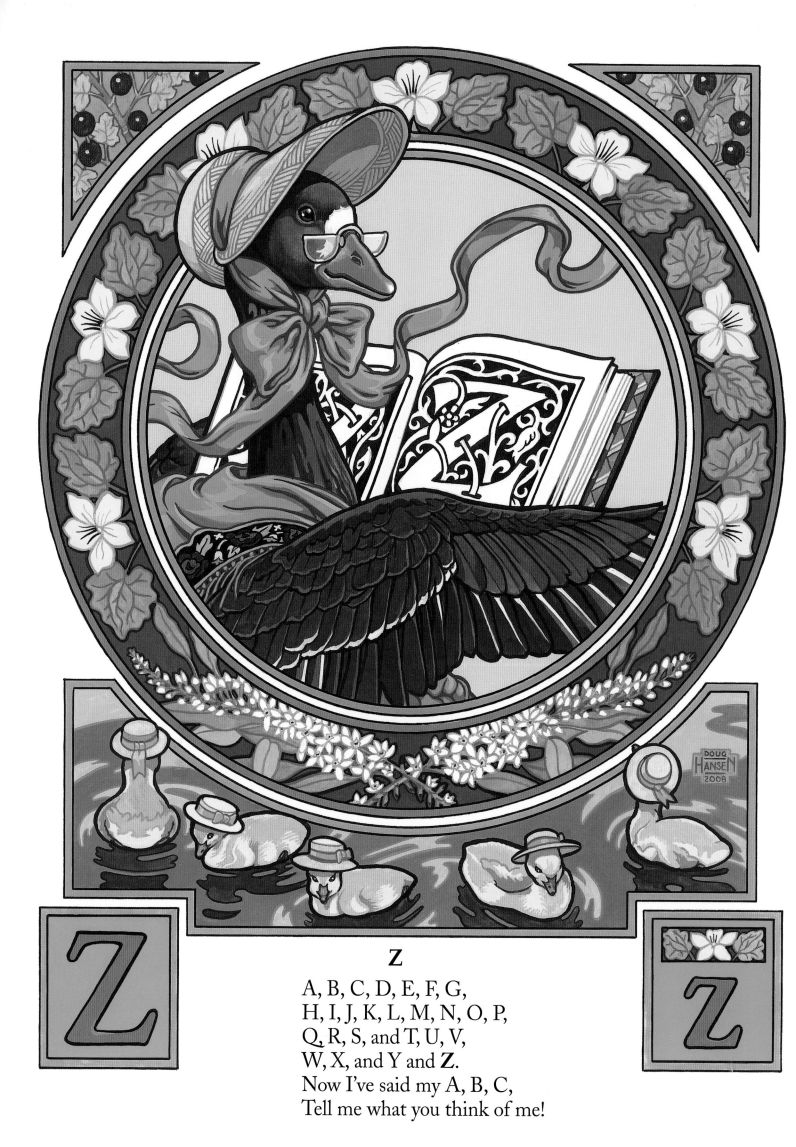

Z

A, B, C, D, E, F, G,
H, I, J, K, L, M, N, O, P,
Q, R, S, and T, U, V,
W, X, and Y and **Z**.
Now I've said my A, B, C,
Tell me what you think of me!

A Guided Tour
with
Mother Goose

Descriptions of the Animals, Plants, and Places in the Pictures

Mother Goose is glad she came to the Golden State, because there is so much to see and discover in California. If you want to find out more about each letter in the book, then follow Mother Goose on this behind-the-scenes tour of the alphabet.*

A is for AIR

An exuberant pig maneuvers his monoplane high over San Francisco Bay. The pig is having so much fun that Mother Goose cannot explain why the "man in brown" brought him down. The famous bridge that now spans the waters of the Golden Gate is shown as it appeared while under construction. The cables were suspended before the roadway was built. Another highflyer is the majestic California Condor pictured in the corner panels. The condor was nearly extinct, but captive breeding has enabled some birds to return to the wild.

B is for BLACKBIRDS

Tricolored Blackbirds are related to the better-known Red-winged Blackbirds that you may have seen. The gregarious Tricolored Blackbirds are found almost exclusively in California and prefer the rice fields and wetlands of the vast Sacramento–San Joaquin River Delta. Tules (or bulrushes) and cattails grow there in profusion. The Cabbage White Butterflies and grasshoppers that decorate the border are food for the blackbirds. Did the artist remember to include all twenty-four birds?

C is for CHAMBER

Newspaper publisher William Randolph Hearst built an opulent residence (now known as Hearst Castle) in the hills above San Simeon. When Marion Davies was at the castle she slept in the richly furnished north Gothic Bedroom. That is the "lady's chamber" shown in the picture. A brant is a kind of a dark-colored sea goose found along the coast. The bird's lacy, white neck patch looks like it could be part of a maid's uniform. This nosy goose is peeking and poking around upstairs and downstairs.

D is for DONKEY

During the California gold rush, prospectors scoured the state for precious metals. This Brown Bear, or California Grizzly, and his old gray donkey find themselves prospecting in the Mojave Desert. The image of a grizzly appears on the California flag, but the only bear now found in California is the Black Bear. The desert landscape in the picture on top features the curious-looking Joshua Tree. The other desert plants are the spiky Century Plant and the edible Prickly-pear Cactus. Have you ever eaten a cactus?

E is for EGGS

A champion black hen lays eggs for gentlemen—in this case the gentlemen are Long-tailed Weasels. These slinky, agile weasels are carnivores. They would prefer a chicken dinner, but eggs for breakfast are just fine. The flowers in the border have a funny-sounding name: Henbit Deadnettle.

* The Mother Goose rhymes in the book are based on those in *Mother Goose*, arranged and edited by Eulalie Osgood Grover and illustrated by Frederick Richardson (Chicago: P. F. Volland, 1915), and *The Real Mother Goose*, illustrated by Blanche Fisher Wright (Chicago: Rand, McNally, 1919).

F is for FIDDLE

After a busy day at harvest time, a tabby cat relaxes and plays his fiddle. Venus, the "evening star," twinkles in the dusk. You can see it just above the barn. Two other things cats enjoy are catnip and chasing rats. The purple blossoms are catnip and hidden in the corners are Fresno Kangaroo Rats. Their elongated hind legs are for two-footed hopping, just like kangaroos.

G is for GARDEN

A rare and dainty Sierra Nevada Red Fox tends a California mission garden. She represents the native people who lived and labored in the mission communities, and she wears simple work clothes and a shawl. The Spanish padres (fathers) established twenty-one missions on El Camino Real (the Royal Road), each a long day's journey from the next. Mission San Luis Rey and the Carmel mission (San Carlos Borromeo de Carmelo) inspired the mission gateway and the beautiful garden in the picture. Mother Goose substituted California flowers for those in the rhyme. "Silver bells" became Mountain Bluebells (upper right corner) and "Pretty maids all in a row" became Pretty Face (upper left corner). "Cockle shells" became the scallop-shell symbol of the pilgrim (on the mission wall). California flowers and butterflies decorate the border. Clockwise from the bottom, see if you can find the Bay Checkerspot Butterfly, Chocolate Lily, Mission Blue Butterfly, Farewell-to-Spring flower, Monarch Butterfly, and Midnight Monkey Flower.

H is for HORSES

"All the king's horses and all the king's men" are gathered in the Presidio of Monterey, but they can't put Humpty Dumpty together again. The Royal Presidio Chapel can be glimpsed in back. The horse is a proud, powerful Andalusian. The king's men are bobcats, with their fine whiskers. These frontier troopers serve the king of Spain in the New World, in the region that was called Alta California years before it became the state of California. The king's personal arms of castles and lions are embroidered on the flag.

I is for INK

If all the world really *were* apple pie, then the earth's crust would be good enough to eat. Can you see the continents in the piecrust? You could make a sandwich from the trees of bread and cheese. Two art students are inking a mural of California explorer Juan Cabrillo's ship, the *San Salvador*. These two Yellow-pine Chipmunks have distinctive stripes that provide protective coloration in the open forests of northern California. They wear berets and smocks when they paint.

J is for JUNE

A Purple Shore Crab waves its toy shovel in greeting. It's the month of June; time to build a big sand castle under the Cayucos pier. Look for the two Brown Pelicans. They are frequently seen patrolling for fish, then plunging dramatically into the Pacific after their prey. The crab used shiny stones, scallop shells, and pelican and gull feathers to decorate the castle. You can find seashells like these on California beaches. The round shell with the petal pattern is a sand dollar.

K is for KITTENS

The sled ride for these three little kittens is at an end. The snowy slopes of the Sierra Nevada are great for winter play, but not when your mittens are lost. One kitten has the right idea and is looking up high. Those mischievous Steller's Jays are hiding the mittens high up in a tree. One jay even has a mitten for a hat. The vivid blue coloring of these bold scavengers contrasts memorably with the drab colors of winter.

L is for LAMB

Basque shepherds came to California from the distant mountains between France and Spain. Mary is a little Basque Shepherd Dog and she's dressed in traditional Basque folk costume. The sheepherder wagon has a door, windows, and a chimney. It is Mary's snug, mobile home when the sheep graze in the vast Owens Valley. Have you ever imagined you could see animal shapes in the clouds?

M is for MOON

San Joaquin Kit Foxes and frisky Western Spotted Skunks love to play at night. If you see a skunk doing a "handstand," watch out! It's ready to spray its defensive scent. The Eyed Sphinx Moth is nocturnal, and the Jimson Weed flower blooms at night. Some people imagine a man in the moon, but others can see a rabbit. Can you see it? Its floppy ears are at the top and its tail is at the bottom. The animals play close to their Los Angeles homes. The houses are Craftsman-style California bungalows, but Kit Foxes actually live in underground burrows.

N is for NORTH WIND

The north wind blows the yellow leaves from the cottonwoods, aspens, and dogwoods of a Yosemite Valley meadow. Towering in the background is Half Dome, the most well-known landmark in Yosemite National Park. It is an imposing granite dome dramatically shaped by ice action. The American Robin stays warm in a log barn typical of pioneer structures once found in the park.

O is for OWL

This extraordinarily wise Great Horned Owl earned his PhD at UC Berkeley (or Cal), the oldest of the University of California campuses. You can tell because he is wearing the doctoral gown, hood, and cap of blue trimmed in gold. The owl is also distinguished with a gold Nobel medal. The owl studies in a Black Oak, and the oak leaves and acorns make a ring around him. Piñon Mice, afraid of being eaten by the owl, cower in the corners.

P is for PUMPKIN

Peter and his wife are California Ground Squirrels that live in a two-story pumpkin house instead of the usual burrow. They are dressed like the hardworking Dust Bowl migrants of the 1930s sometimes known as Okies. The milky sky suggests a hot summer day in the San Joaquin Valley, and the oak trees silhouetted in the distance show where precious water runs. Ground squirrels enjoy grasses, seeds, fruits, nuts, and gourds. A common native gourd, called "Stinking Gourd" because of its smelly leaves, is pictured in the corners, and pretty yellow pumpkin flowers make a decoration that Peter likes.

Q is for QUICK

A California Red-legged Frog named Jack makes a quick jump for joy over the candle in his Calaveras County gold camp. Jack is a forty-niner, a gold hunter from 1849. Unlike most prospectors, Jack has already found piles of gold. Can you find the big gold nuggets in the corners? They look a little like popcorn. This is the "Celebrated Jumping Frog" chronicled in Mark Twain's humorous story set in the mining town of Angel's Camp. Marsh Marigold leaves and more frogs line up to make a border.

R is for RAIN

A Great Blue Heron holds an umbrella to keep the rain from her young. The herons are wondering if there are any fish to eat in the pond at the Japanese Tea Garden in San Francisco's Golden Gate Park. The drum bridge and Buddhist pagoda are reflected in the rippling water. Look at the side panels and you can probably guess which rainy-weather friends are the Giant Salamander, California Tiger Salamander, and Banana Slug. Vividly colored mushrooms brighten up the rainy day.

S is for SEASHELLS

This pretty sea otter lives in Morro Bay with her otter friends and sells her seashells on the seashore. Her shells come from all over the world. The imposing Morro Rock is the last of a chain of volcanic peaks called the Nine Sisters. Otters swim through underwater forests of Giant Kelp in search of Red Abalones for a meal. Can you search for the abalones and kelp in the picture?

T is for TOYS

This Acorn Woodpecker makes and sells all kinds of wooden toys in his toy store. His comical appearance and colorful plumage make him look like one of his own toy creations. He is a master woodworker and his tools are stored carefully above his workbench.

U is for UP

Jack and Jill are California Bighorn Sheep. They climbed high up the mountain in Lassen Volcanic National Park to fetch their pail of water. Bighorn sheep like high rocky places where no predators can surprise them. Can you follow the path to their house far below? The sheep are no longer found in the park, but a few are still seen elsewhere along the Sierra crest. Near the sheep's feet are two plain-looking aquatic songbirds called American Dippers, or Water Ouzels. The dipper dives into fast-moving streams in search of food and can walk and see underwater.

V is for VALE

A pair of White-tailed Jackrabbits watch as their baby sleeps. In winter their brownish-colored fur turns to white except for the tips of the ears. Their cozy log cabin is sheltered in a broad river valley in the snowy Klamath National Forest. The stars of the winter sky stand out brightly in the mountain darkness. The brightest star in the left corner is Sirius, the nose of the dog in the constellation of Canis Major. In the right corner, look for a row of three stars that make the belt of Orion, the hunter.

W is for WOMAN

The old woman living in the antique shoe is a California Quail, the state bird of California. She may have twelve to sixteen offspring. How many are in this picture? Adults have the distinctive teardrop-shaped plume on their heads, but the youngsters look like they are having a bad feather day. Quails eat the blue Sky Lupine in the background. Snails are one of their other favorite treats. One bird is following a snail. Can you name the games the other birds are playing?

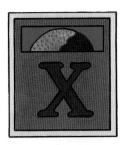

X

Not many words begin with the letter X, but Mother Goose noticed that the mark on a hot-cross bun can look just look like an X. The buns are traditional treats served on Good Friday at Easter time. Crosses can be made of sweet pastry dough or icing. You can find the ingredients to make the buns, including currants, eggs, and sugar, scattered in the foreground. Yellow-headed Blackbirds were chosen as bakers because their Latin scientific name, *Xanthocephalus xanthocephalus*, begins with an X. How many buns could you buy with the pennies in the picture? Or would you buy some of the other goodies?

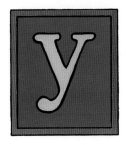

Y is for YELLOW

Bobby Shaftoe is a Golden-mantled Ground Squirrel who has joined the United States Navy and gone to sea. He is dressed in his best blue uniform and is making himself neat for a day ashore. In earlier times Bobby's knickers might have sported silver buckles but here he wears the bell bottoms made popular by the U.S. Navy. The armored cruiser USS *California* is anchored in San Diego Bay, and you can find the historic Hotel del Coronado in the distance. In 1914 the USS *California* was renamed the USS *San Diego*. Sailors learn to follow signals from the silver bosun's pipe and in their spare time like to make fancy knots like this one, called a "monkey's fist."

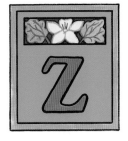

Z

Now we have finished our visit to California with Mother Goose. She is a Greater White-fronted Goose. The borders are filled with all kinds of plants with "goose" names, including Gooseberry Currant (with the red berries), Goose Neck (with white flowers), and Goosefoot Violet (with yellow flowers). Mother Goose's goslings are swimming below. They are still learning their ABCs. Have you learned yours?

Acknowledgments

Several remarkable people deserve my thanks for their generosity of spirit, professionalism, and willingness to help me make an illustrated book about animals dressed as nursery rhyme characters.

I spoke to a friend, author David Mas Masumoto, when I couldn't interest a publisher in my book and I didn't know where to go next. Mas thoughtfully advised me to approach Heyday Books with my California ABC idea. My thanks to the charming, insightful and hard-working people at Heyday Books. Acquisitions Editor Gayle Wattawa, Editorial Director Jeannine Gendar, Production Editor Diane Lee, Art Director Lorraine Rath, and Marketing & Publicity Director Wendy Rockett have each in turn guided me and enriched this book.

When publisher Malcolm Margolin told me that Heyday Books would publish *Mother Goose in California*, I felt like I had found the golden ticket in Roald Dahl's book *Charlie and the Chocolate Factory*. I still feel that way. The publication of these pictures is a landmark in my career as an illustrator, and it means so much to me to be able to share them in print. My thanks to the charming and insightful people I've worked with at Heyday Books, particularly Acquisitions Editor Gayle Wattawa, for helping make this book a reality.

I received unfailing support from everyone I contacted at the Henry Madden Library, at California State University, Fresno. Angelica Carpenter, Curator of the Arne Nixon Center for the Study of Children's Literature, and Library Assistant Jennifer Crow gave me access to important books in the collection. Systems Librarian Patrick Newell advised me on issues about work in the public domain. I particularly appreciate the immediate and wholehearted support I received from Ms. Carpenter. She generously put me in touch with every editor and artist of her acquaintance who might help me get published.

My brother Rob Hansen is a field biologist and ornithologist, and he is a captivating speaker on wildlife and the natural environment. His knowledge of the ecology of the San Joaquin Valley and the Sierra is profound. It was Rob who came to my assistance with answers to questions like "What is a cute-looking animal that has lots of offspring?" Answer: the California Quail (for the old woman who lived in a shoe). Or "What is a thieving bird I would find in the Sierra during winter?" Answer: Steller's Jay (for the three little kittens). Rob coached me on details of the animals' habits, behavior, and appearance. I would have been lost without access to such a reliable and ready resource.

This book required several summers and many holidays in the studio. My wife, Susan, understood what this project meant to me, and she quietly encouraged my wholehearted and serious application to its completion. She was my consultant on color choices for borders and backgrounds, and my audience of one as each picture was completed.

Finally, I am grateful to my family and my friends in Fresno, who have responded so enthusiastically while this work was in progress and who have encouraged and welcomed my illustrations through the years.

Doug Hansen